Cober's Choice

Starfish-top view

Starfish-bottom view

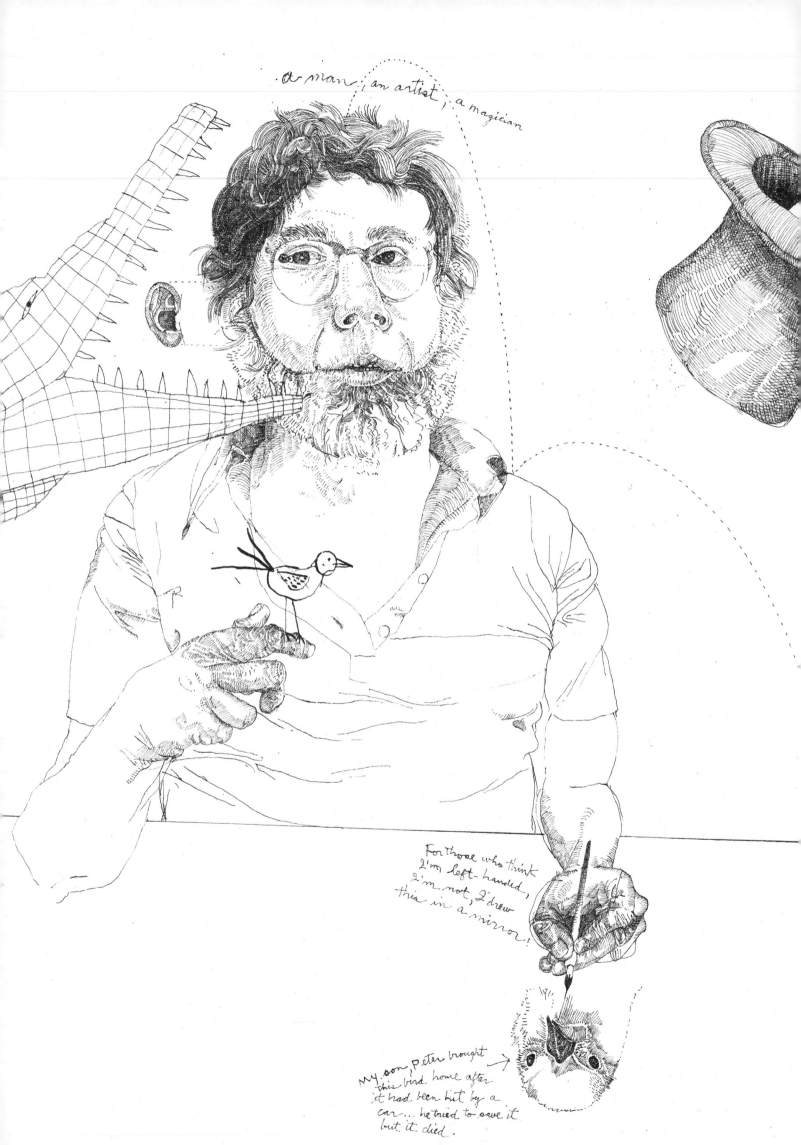

. a man , an artist , a magician

For those who think
I'm left-handed,
I'm not, I drew
this in a mirror!

my son, Peter brought
this bird home after
it had been hit by a
car... he tried to save it
but it died.

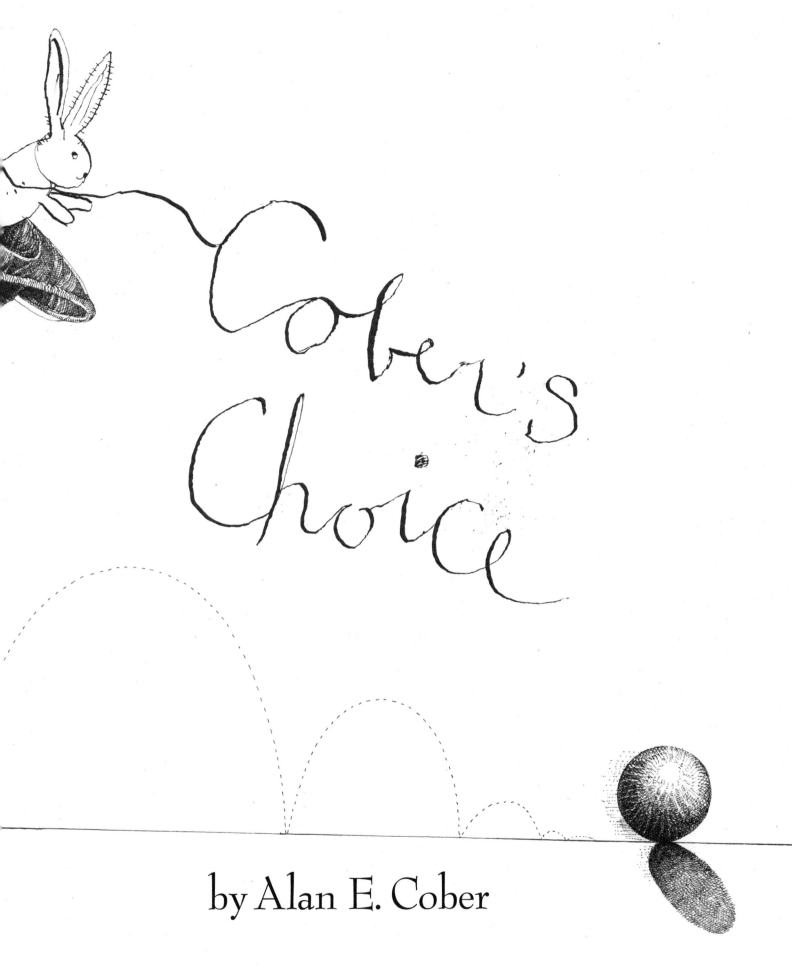

Cober's Choice

by Alan E. Cober

A Unicorn Book E. P. Dutton New York

I wish to thank the following:

Richard Gangel and *Sports Illustrated* for use of "Opossum" and "Salmon."

Bo Costello of Case, Willis, Harwood and Mead Paper for use of the jacket art.

Donald Todd, taxidermist, of Yorktown Heights, New York.

Teatown Lake Reservation, Ossining, New York, for use of their nature collection.

Library of Congress Cataloging in Publication Data

Cober, Alan E. Cober's choice.
(A Unicorn book)

SUMMARY: Brief text and illustrations introduce the
characteristics of a variety of animals that the
illustrator finds particularly interesting.

1. Animals—Pictorial works. [1. Animals—Pictorial works]
I. Title.
QL50.C65 1979 741.9'73 79-11882 ISBN: 0-525-28065-0

Published in the United States by E. P. Dutton, a Division
of Elsevier-Dutton Publishing Company, Inc., New York
Published simultaneously in Canada by Clarke,
Irwin & Company Limited, Toronto and Vancouver
Editor: Emilie McLeod Designer: Meri Shardin

Printed in the U.S.A. First Edition
10 9 8 7 6 5 4 3 2 1

to Ellen,
my first choice

1.

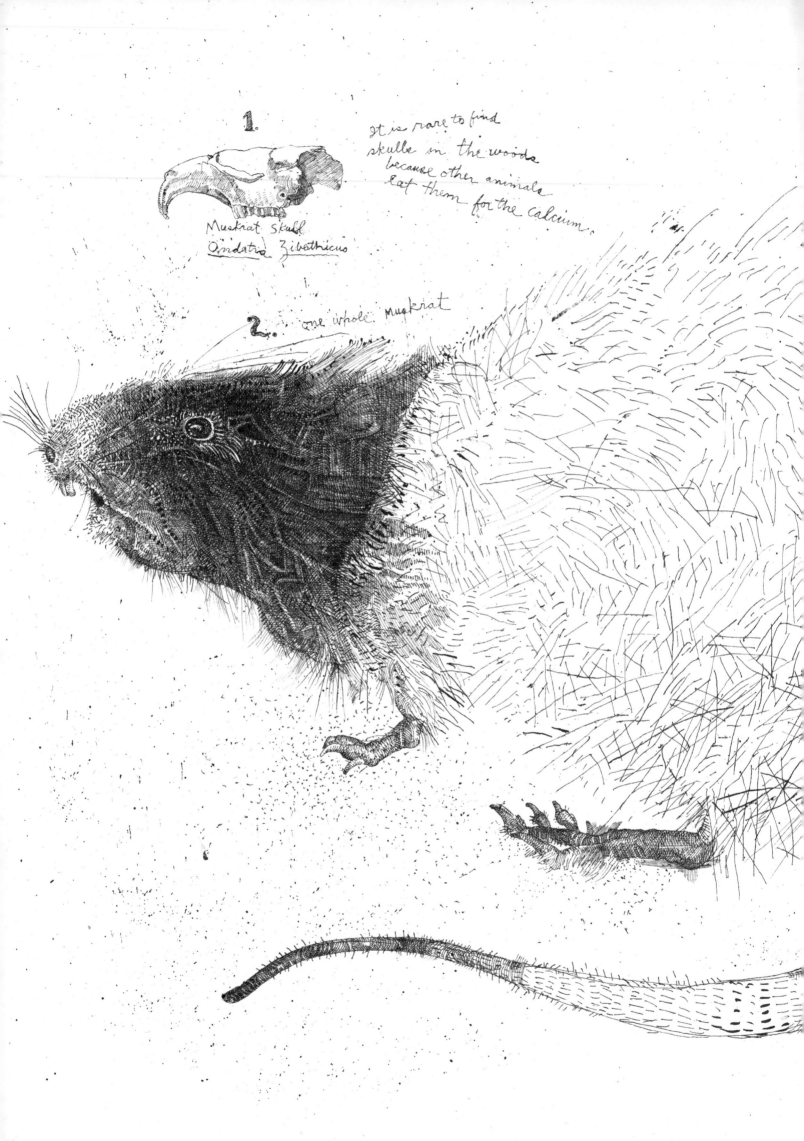

Muskrat Skull
Ondatra Zibethicus

It is rare to find
skulls in the woods
because other animals
eat them for the calcium.

2. one whole Muskrat

MUSKRAT

I was scared by a muskrat once when I was fishing from
a riverbank. I was ten. The fish were scared, too.
Muskrats are rodents who live in water. Their hind feet
are webbed like a duck's, with claws.

PHEASANT

Pheasants walk through my yard. Nine years ago I bought
a stuffed one to draw.

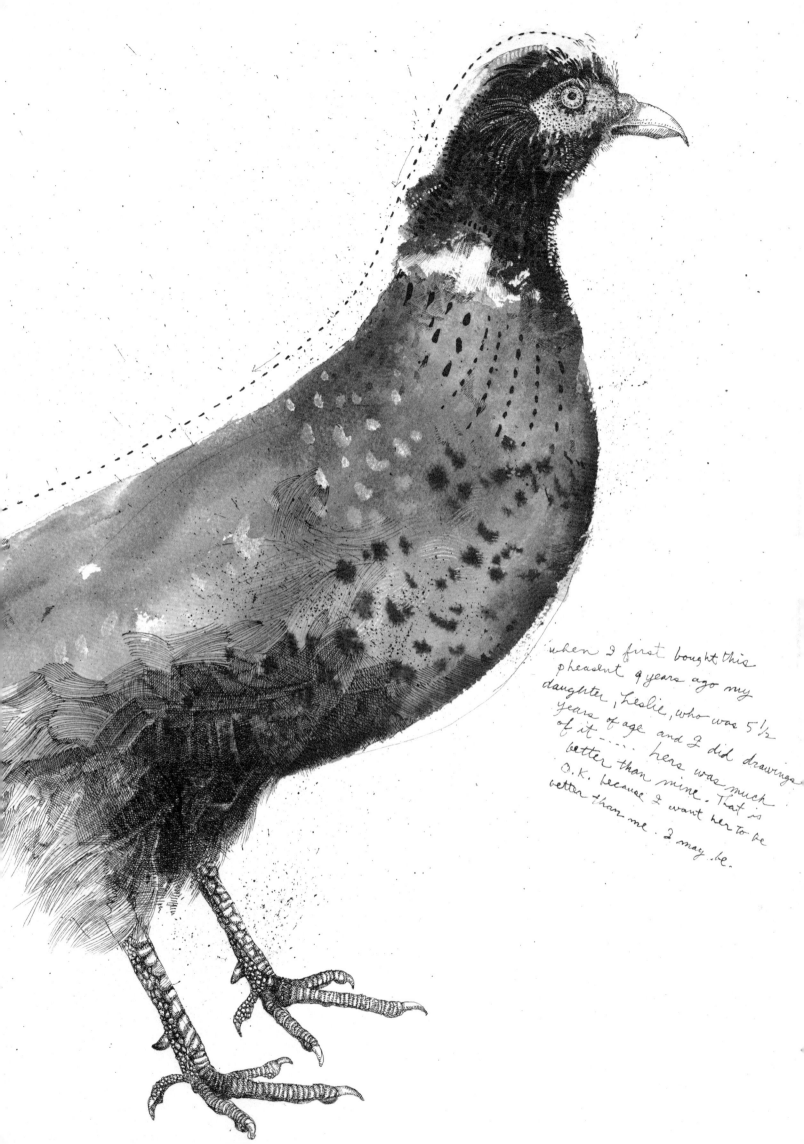

when I first bought this
pheasant 9 years ago my
daughter, Leslie, who was 5½
years of age and I did drawings
of it ---... hers was much
better than mine. That is
O.K. because I want her to be
better than me. I may be.

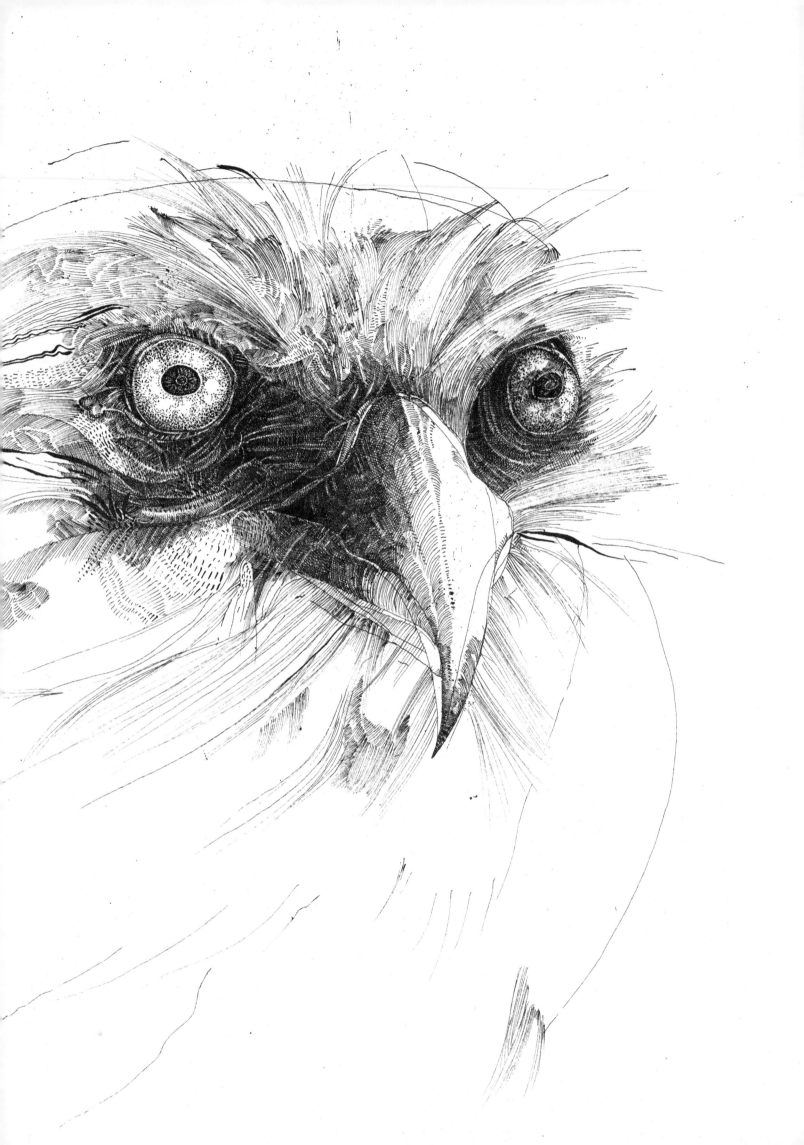

FALCON

This falcon came from an antique shop on Cape Cod. My friends brought it home to New York for me, because it wouldn't fit in my car.

I like its face, particularly the feathers and beak.

It has a broken wing.

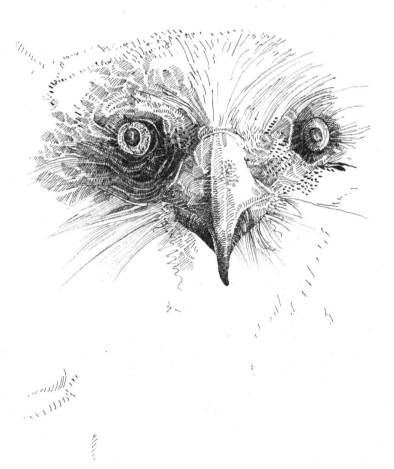

SALMON, *the Eastern or Atlantic*

Fish usually swim in schools, in the same direction, but
these salmon came from a taxidermist. Only the fins,
skin, jaw, and teeth were part of the live salmon.
The eyes are made of glass and plastic. All kinds of eyes
can be bought in a taxidermy supply shop.

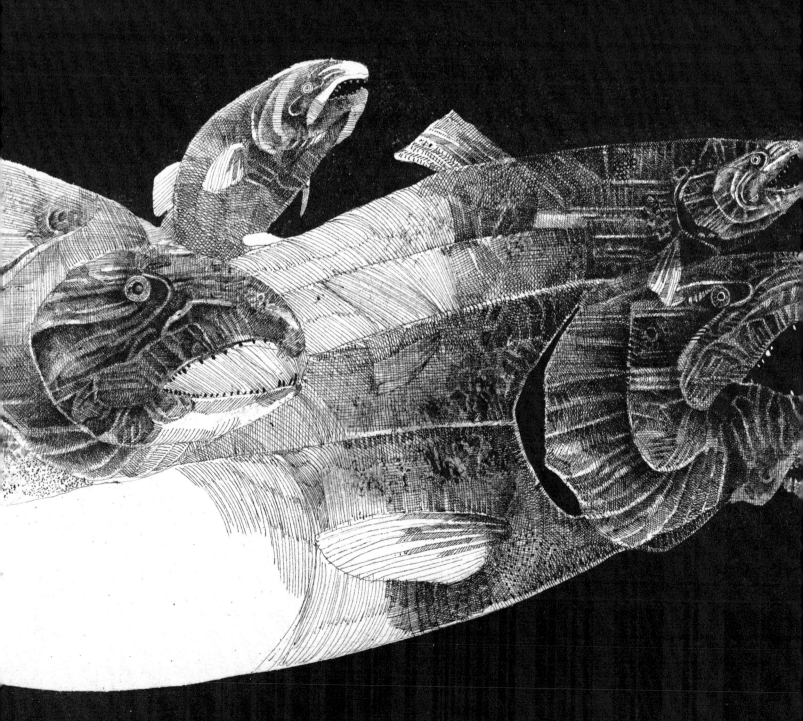

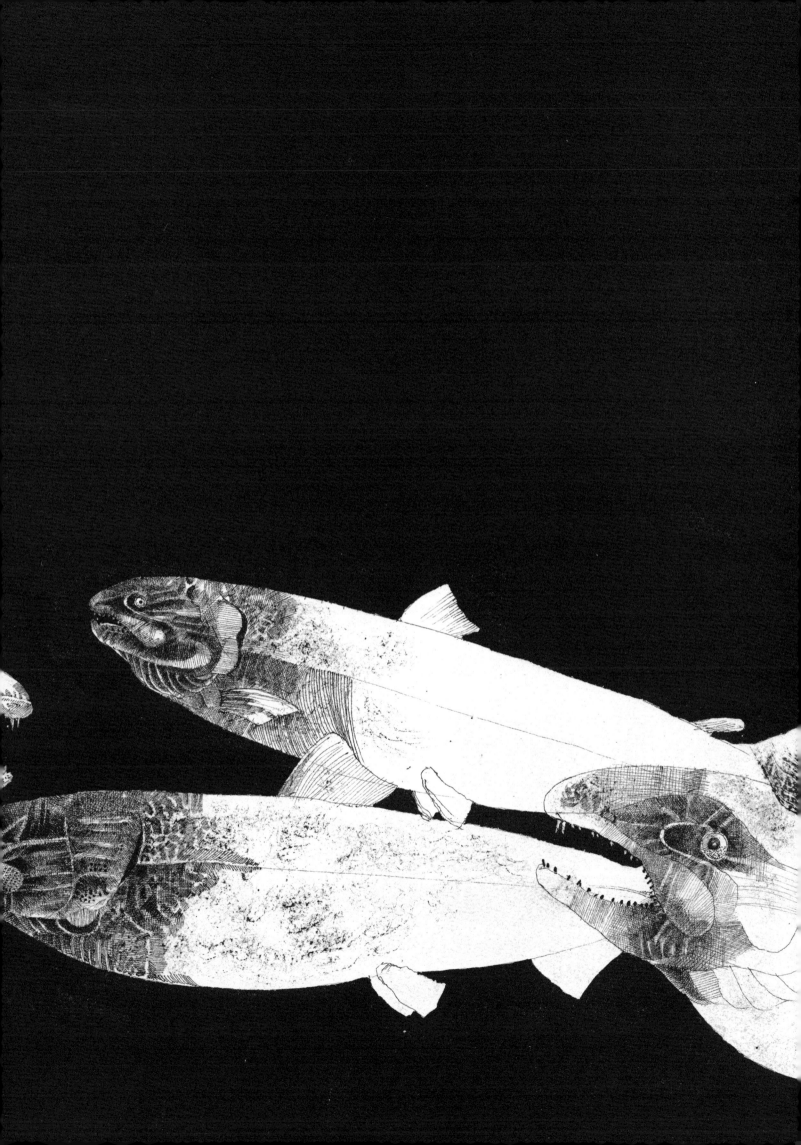

CROW

I like this stuffed crow. (It might even be a raven.)
I borrowed it from the artist Robert Andrew Parker.

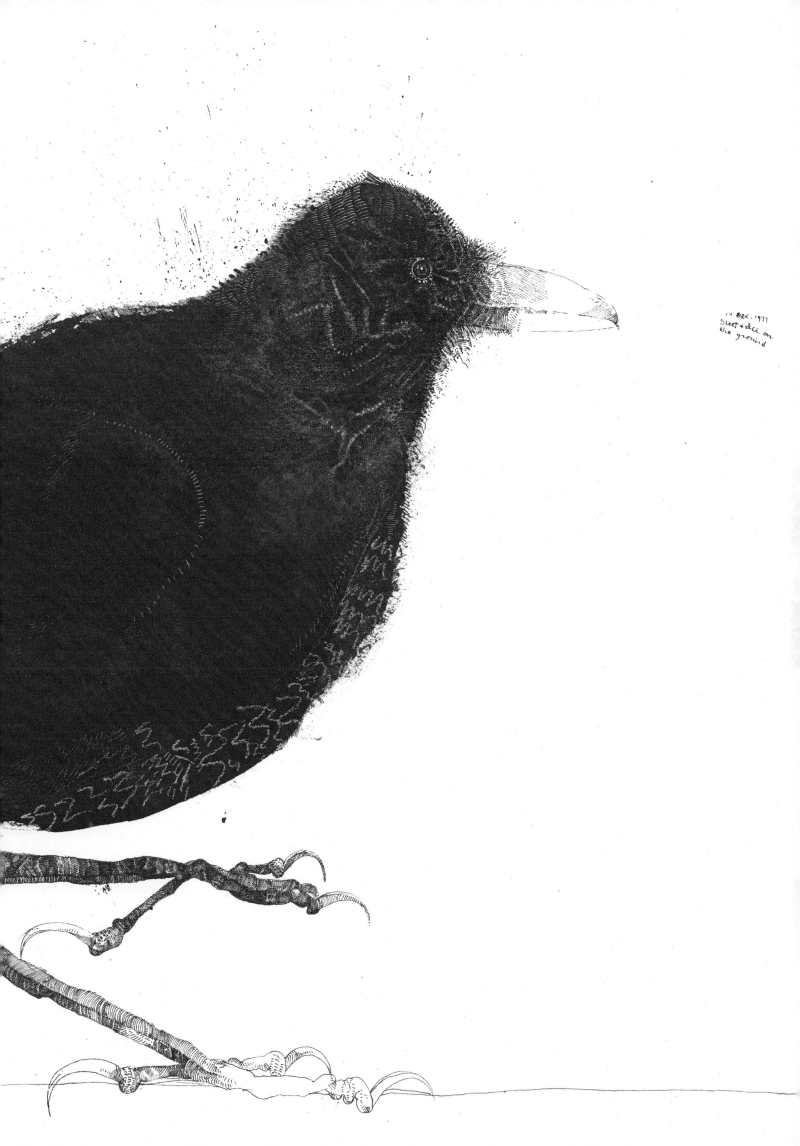

14 DEC. 1977
Sleet + slush on
the ground

ALLIGATOR

I saw a great many alligators in Florida last winter—
almost too many. I drew this one partly from my stuffed
alligator and partly from sketches I made in Florida.

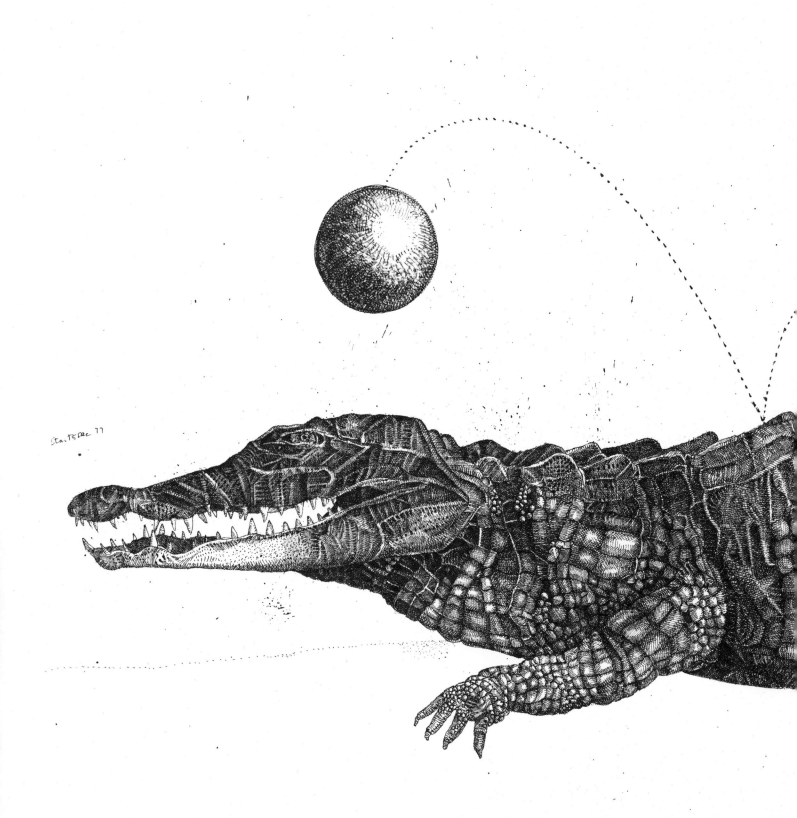

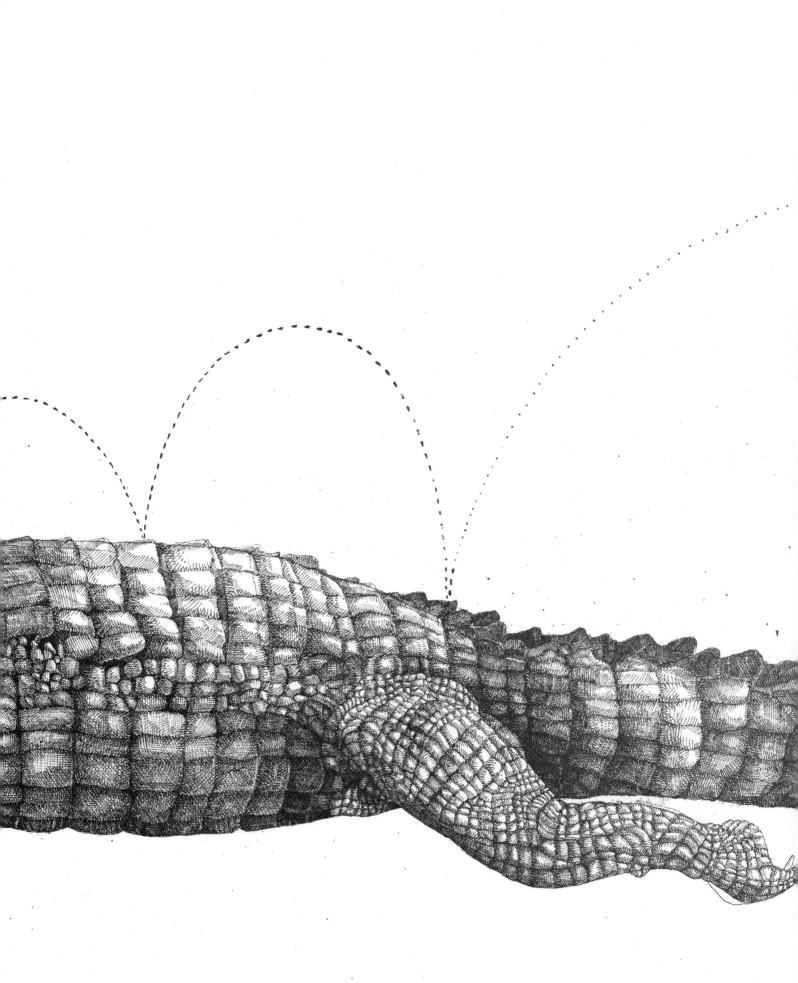

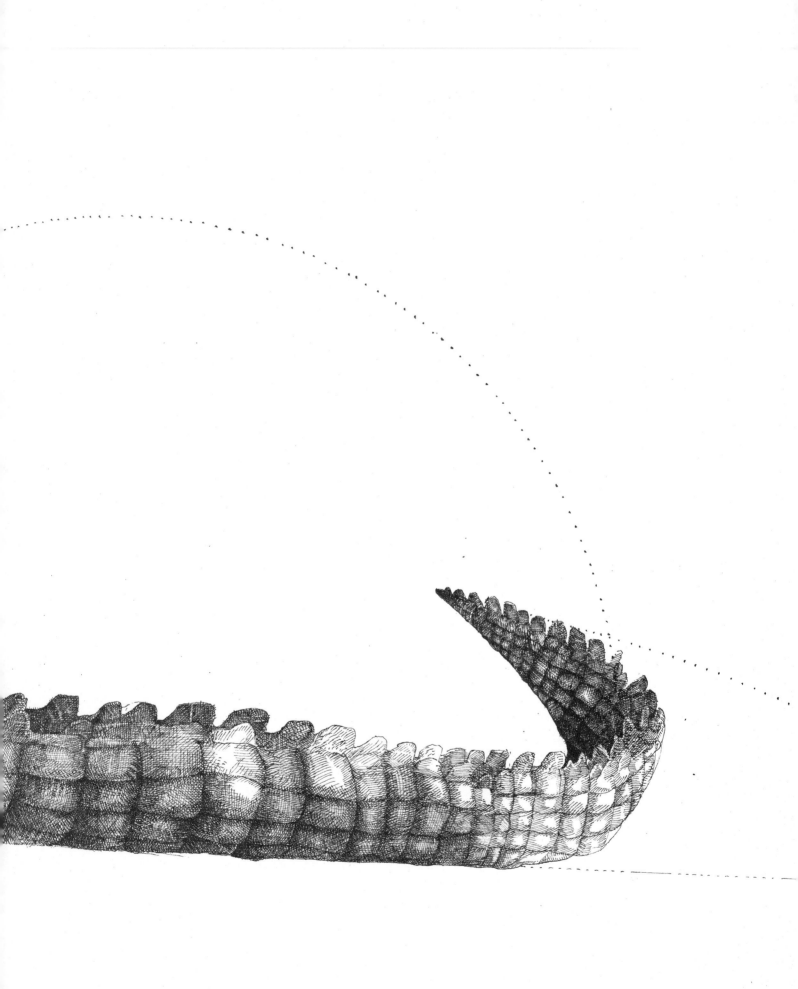

12 DEC 1977

HORSESHOE CRAB

Peter, my son, found this crab shell on the beach at
Sandwich. A horseshoe crab outgrows and casts off its
shell—legs and all. The shell is brittle, with a hinge
in the middle. The tail is very sharp and leaves a line
in the sand behind the crab as it crawls.
Peter is always finding stuff for me to draw.

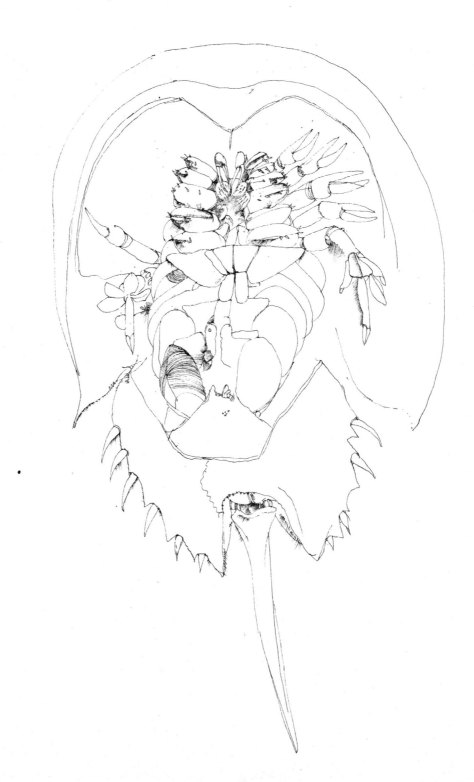

CRAB

I drew this crab in Puerto Rico. In Spanish, "juey" means
"crab." The waiters at the hotel gave it to me on a
string as a joke. So, I drew it.

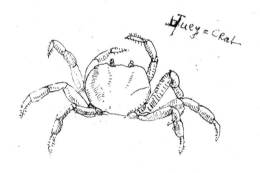

Juey = Crab

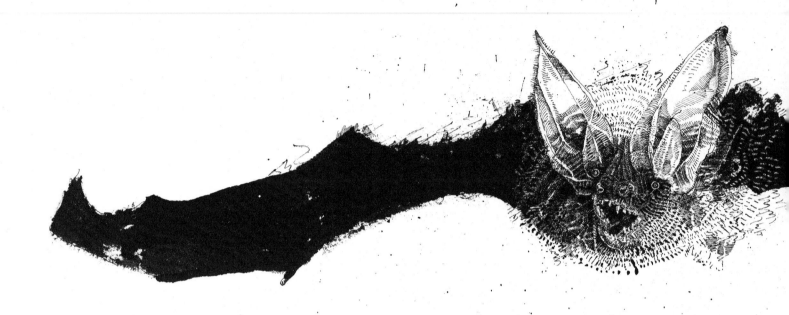

a bat skull

actual size is 2 ½ mm or about 1 inch

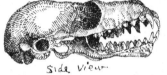

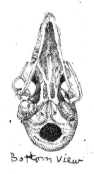

Side View

Bottom View

a bat's rib cage
actual size is 2.2 mm or 7/8
of an inch

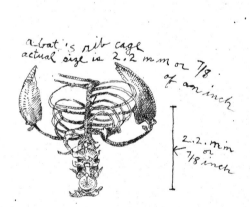

2.2 mm
or
7/8 inch

BAT

Inside and out. Taxidermists usually make a frame of metal or wood to support an animal skin, or use ready-made forms. The skeletons are not used. This bat's wings are like leather, with the five bones, like finger bones, still in them.

CHICKEN

Several months ago I rented two stuffed chickens from Schoepfer's animal rental agency in New York City. This Rhode Island Red and the leghorn rooster on the cover were stuffed many years ago. They have been rented by artists who want their models to hold still but who don't like to draw from photographs.

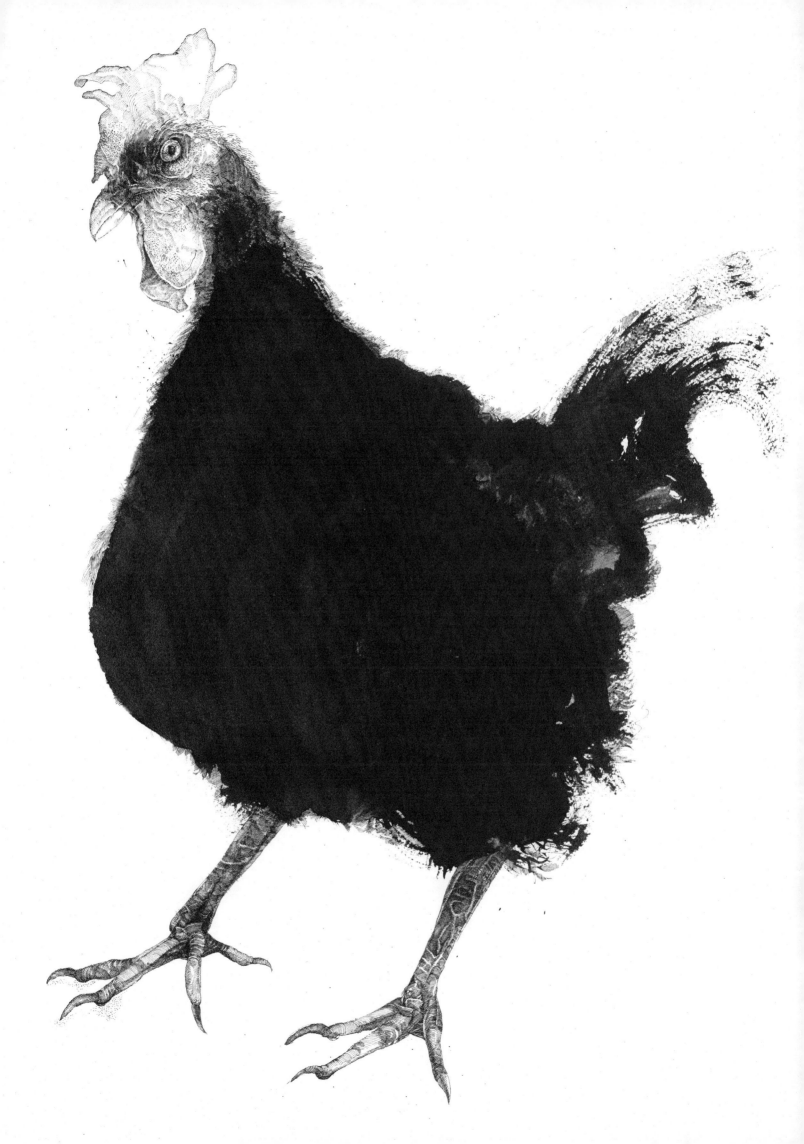

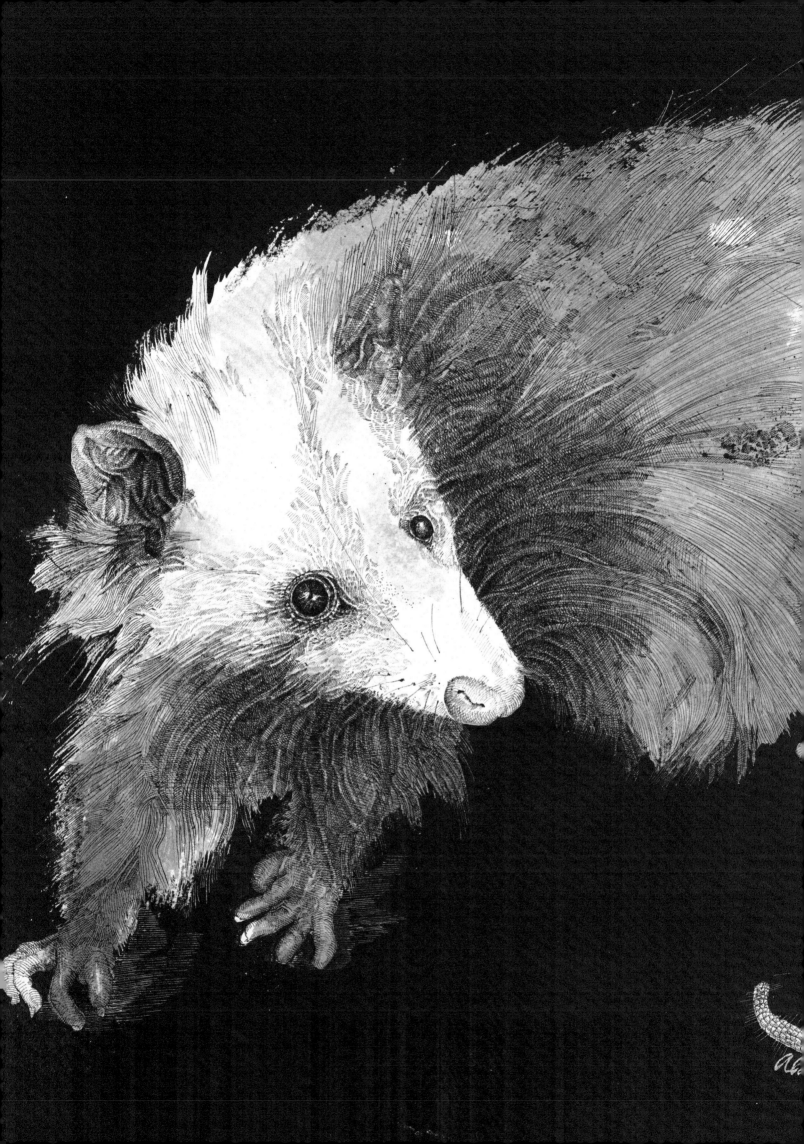

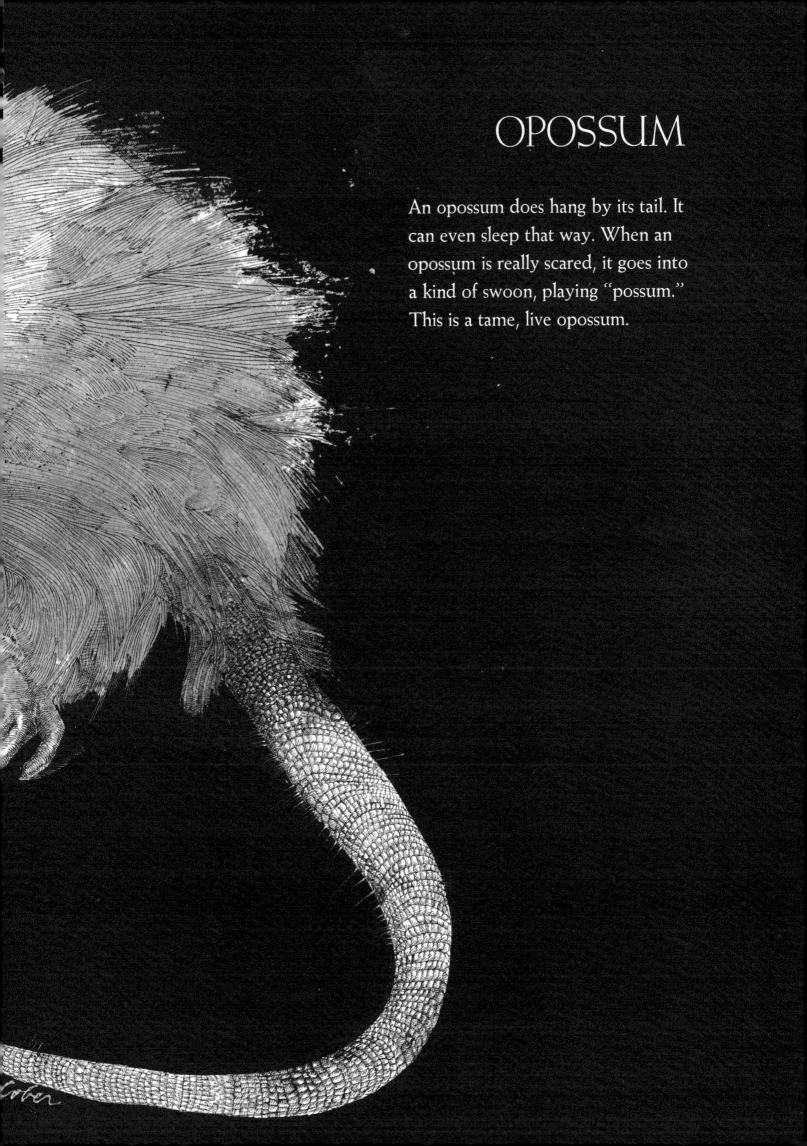

OPOSSUM

An opossum does hang by its tail. It can even sleep that way. When an opossum is really scared, it goes into a kind of swoon, playing "possum." This is a tame, live opossum.

GROUNDHOG

Groundhogs eat and sleep in
underground tunnels.
Some people think they predict
when spring is coming on
Groundhog Day, February 2.
If a groundhog sees its
shadow, winter will last six
more weeks.
I see groundhogs standing
on their hind legs, eating
from my crab apple tree.

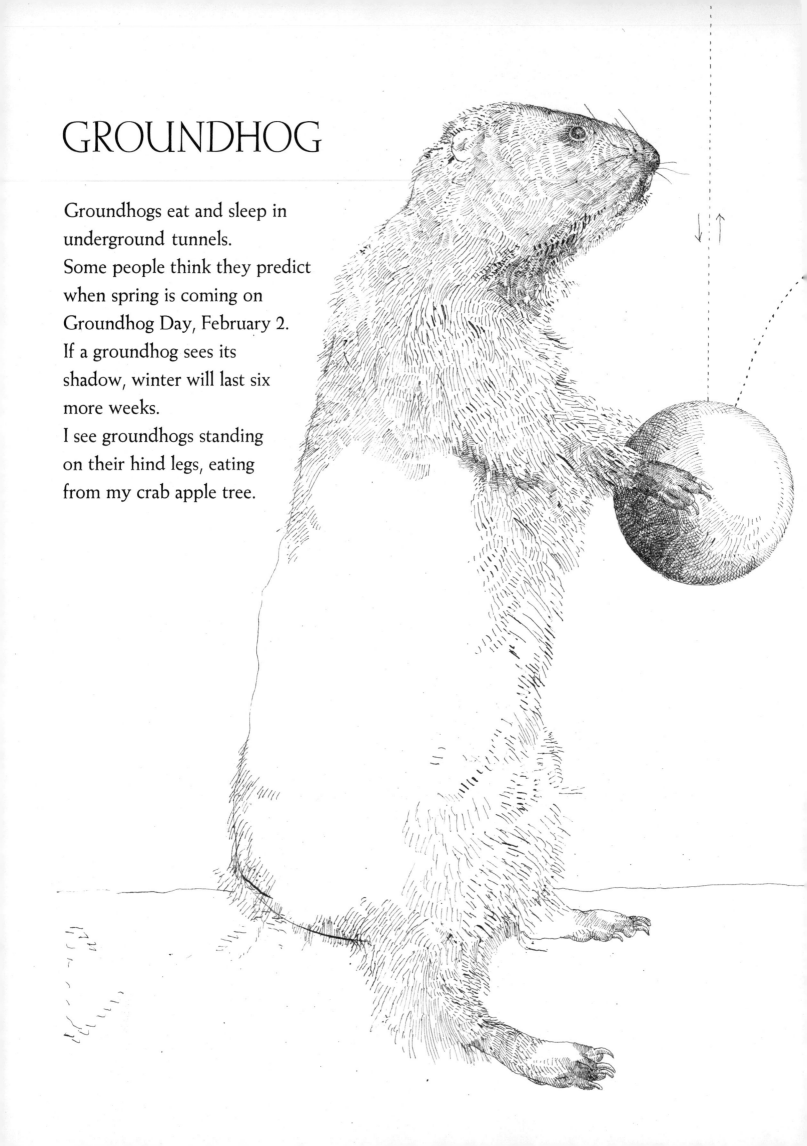

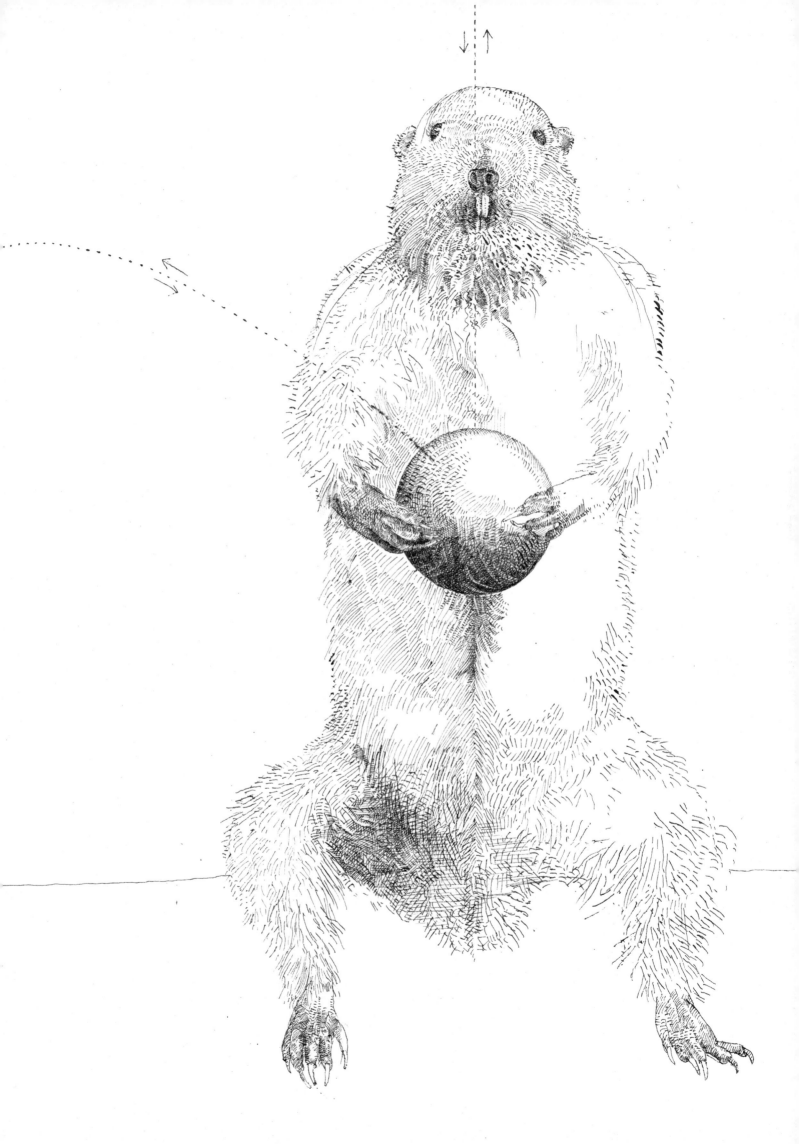

OWL

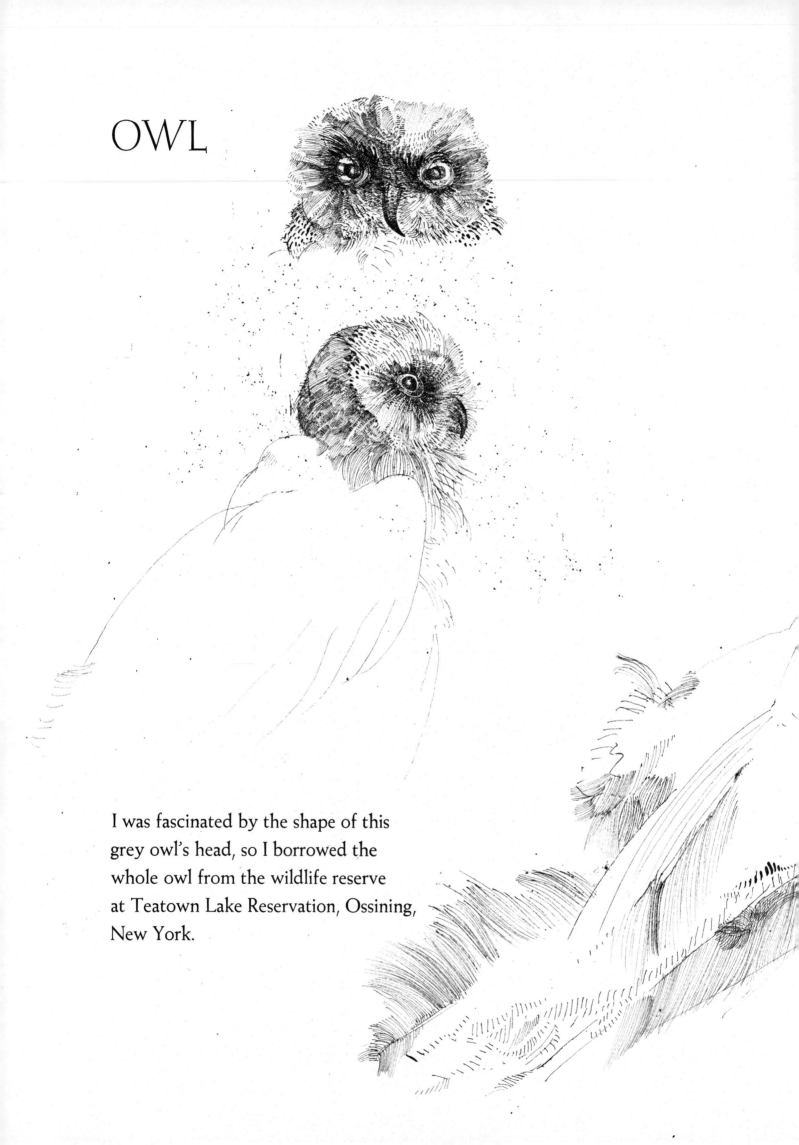

I was fascinated by the shape of this
grey owl's head, so I borrowed the
whole owl from the wildlife reserve
at Teatown Lake Reservation, Ossining,
New York.

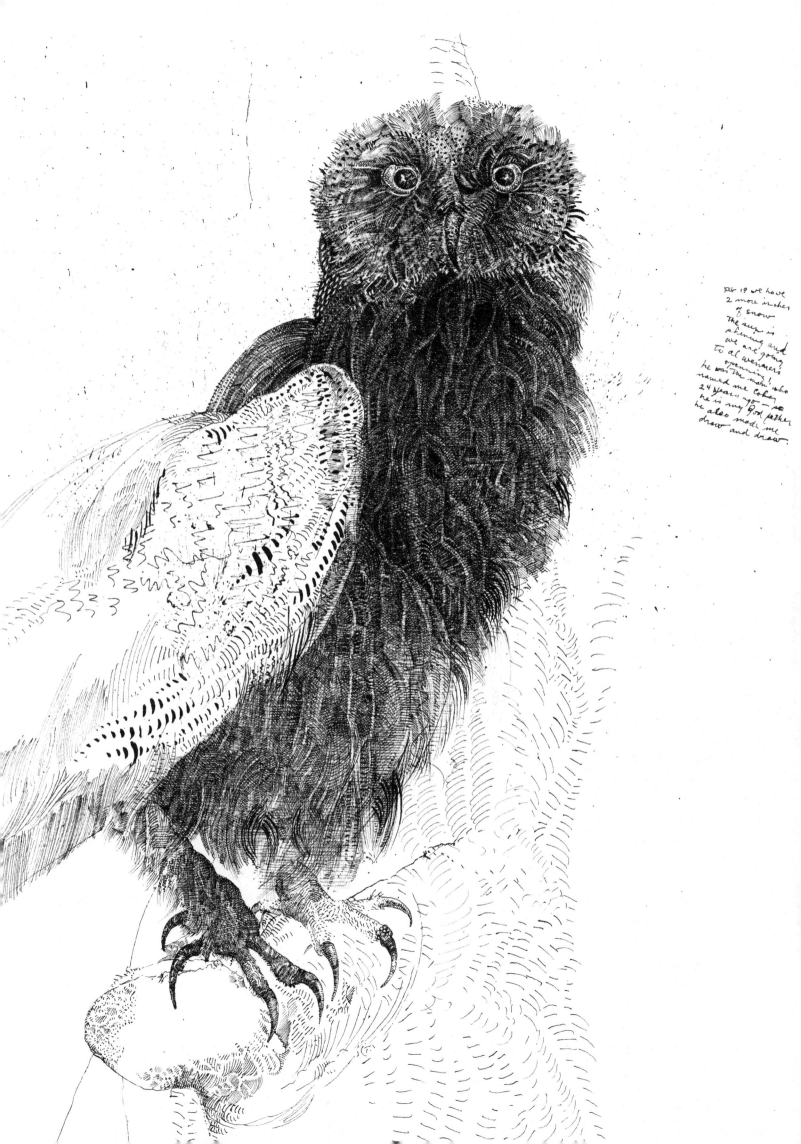

Feb 19 we have
2 more inches
of snow
The sun is
shining and
we are going
to al wieners
opening
he was the man who
named me Cokey so
24 years ago — so
he is my Godfather
he also made me
draw and draw.

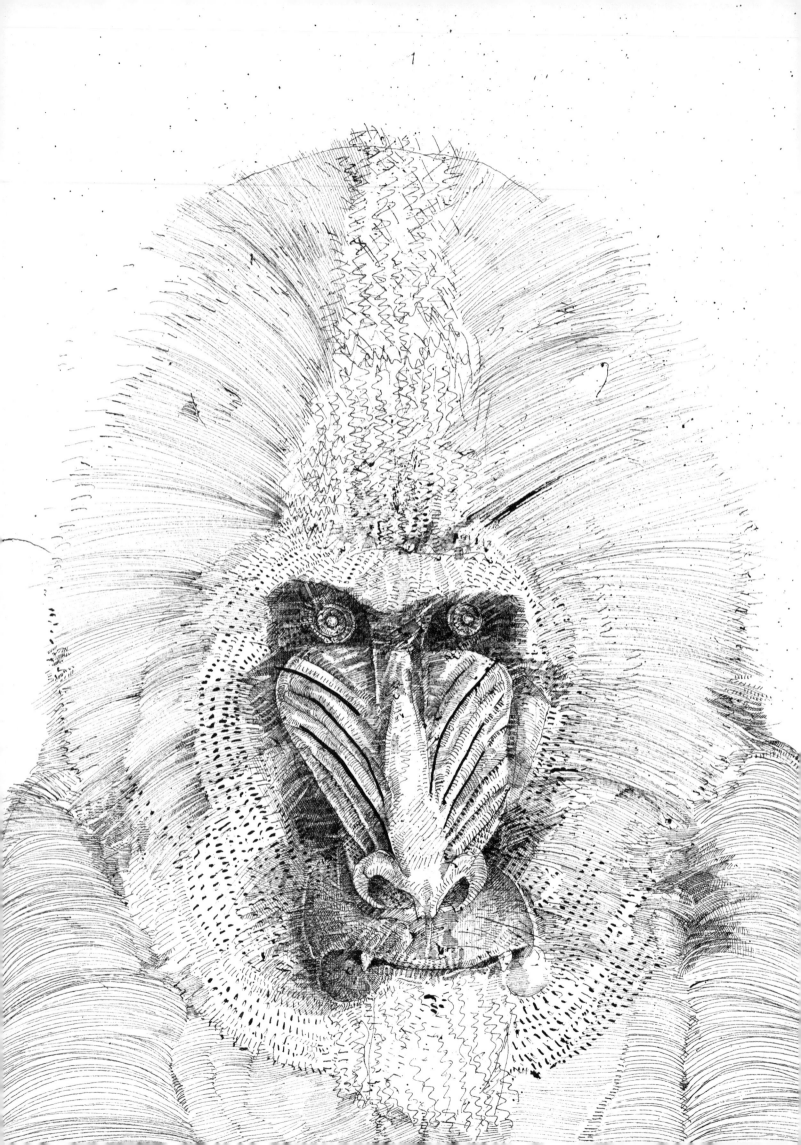

MANDRILL

This is the portrait of a patriarch—the father of many
mandrills who live in the Bronx Zoo.
I drew his portrait there.
The mandrill is a West African baboon.

SKATE

Dead creatures fascinate me. They keep
changing as they decay. I was careful to sit
to windward when I drew this
skate on the beach.

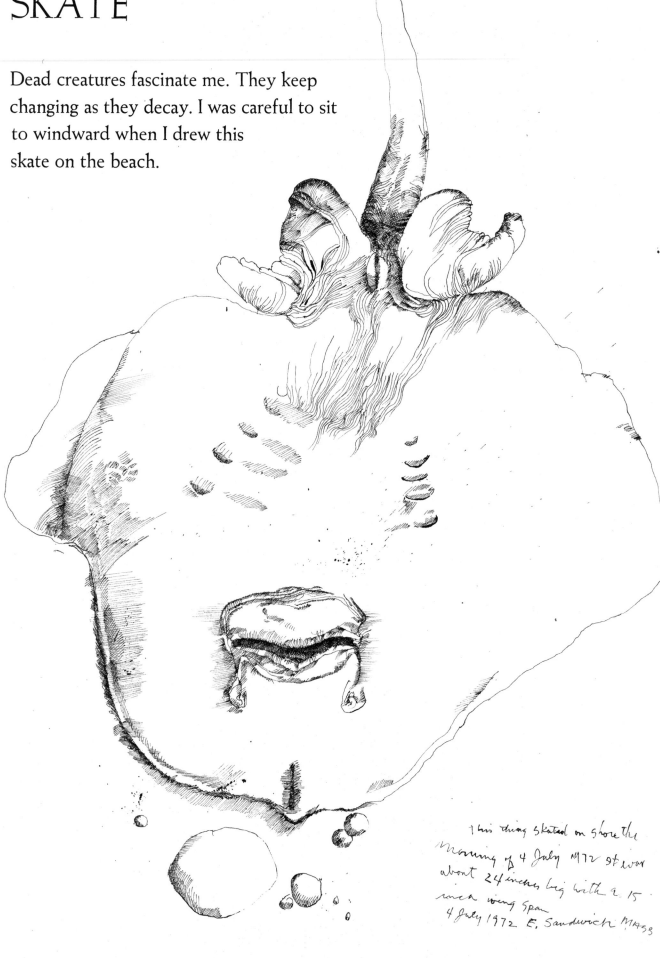

This thing skated on shore the
morning of 4 July 1972 & was
about 24 inches big with a 15
inch wing span
4 July 1972 E. Sandwich MASS

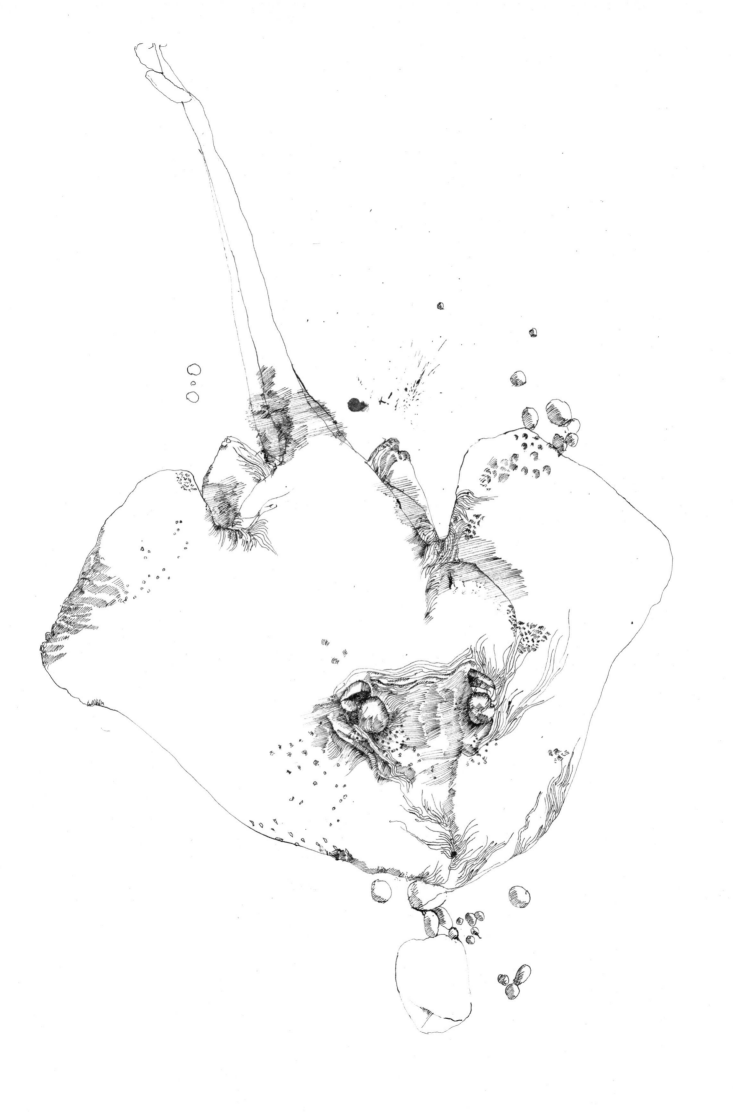

RACCOON

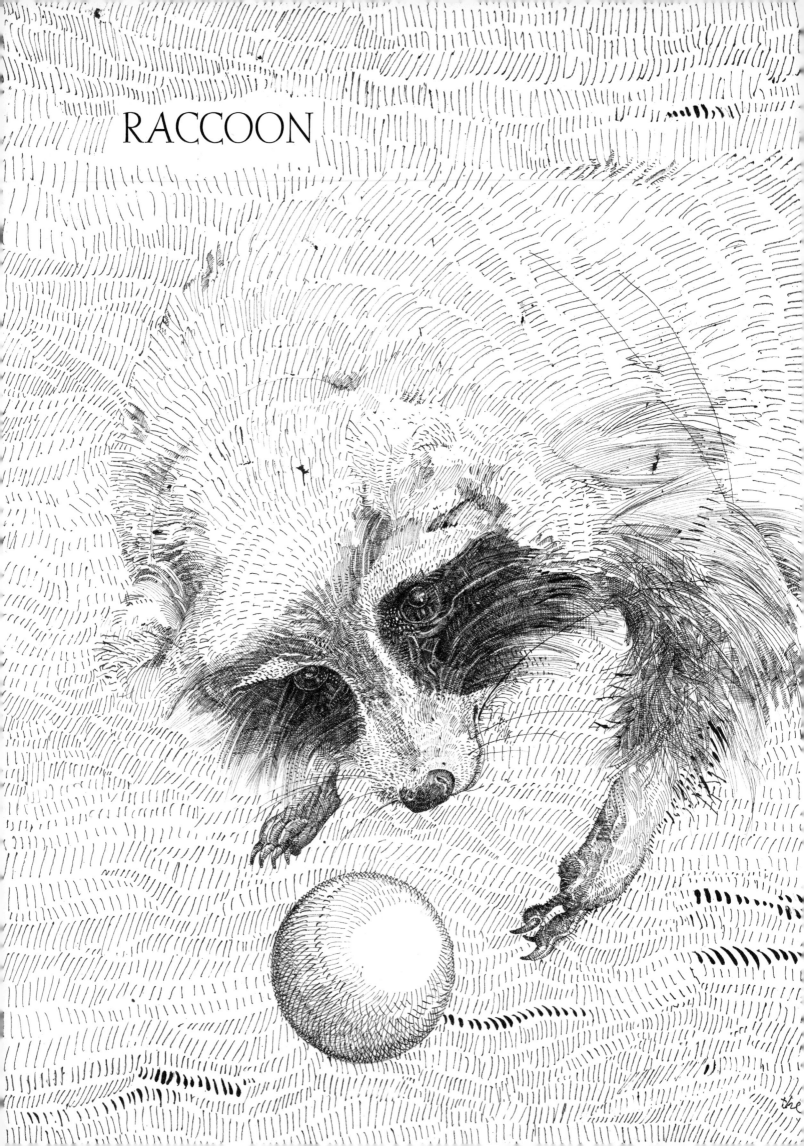

Raccoons use their front paws almost like hands, and I like to think they can play ball. Their faces are masked like clowns'; their hair is coarse, like grass.

In the late fifties with the popularity of Davey Crockett and Daniel Boone on T.V. a lot of raccoons were killed for raccoon caps.

This Raccoon keeps knocking over and eating the garbage and big mess. The

RATTLESNAKE

A handsome diamondback—stuffed. The rattle is at the
tail end of the snake and is made of horny, interlocking
rings. It makes a buzzing sound—a warning—when the
snake is startled or frightened.
The fangs are hollow and hold venom.

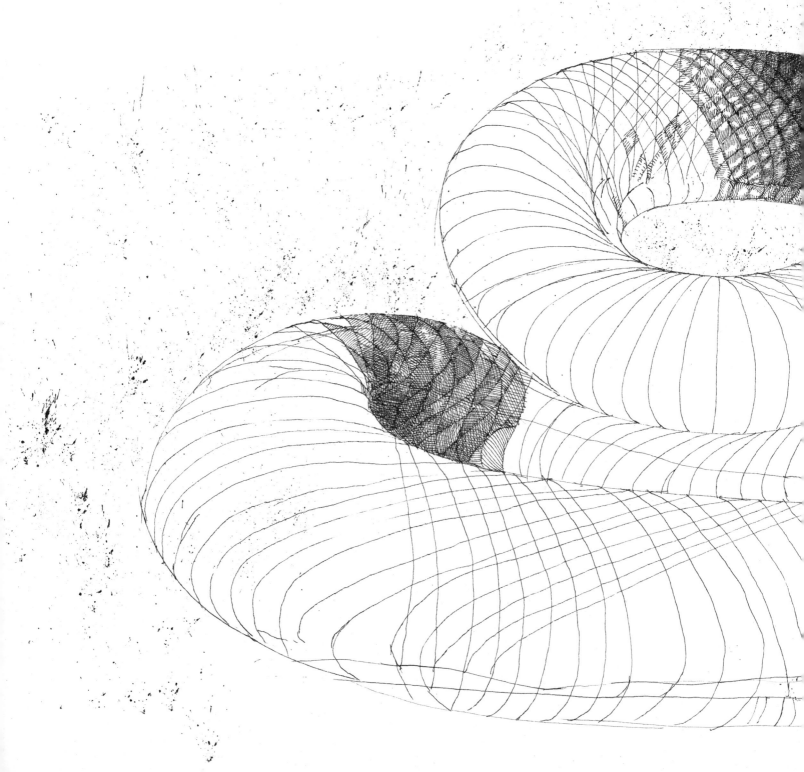

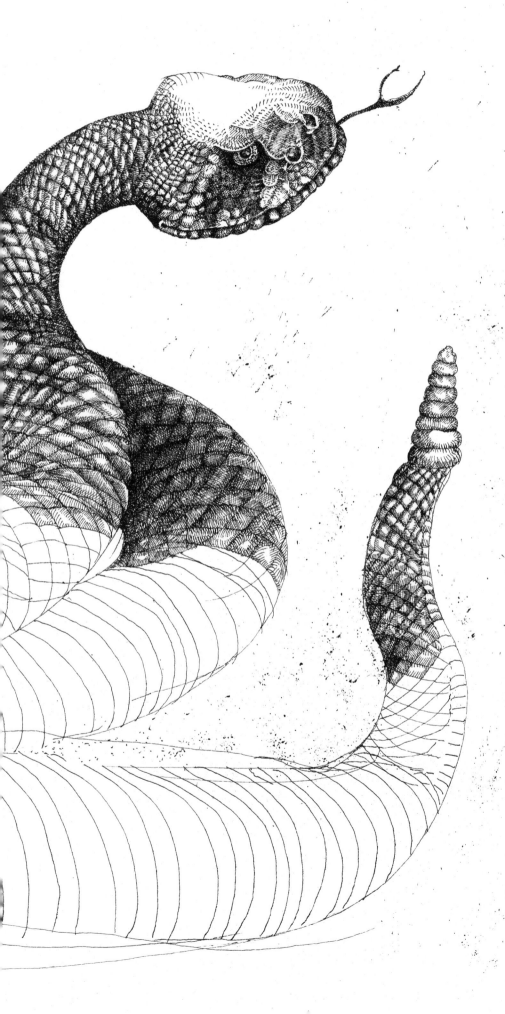

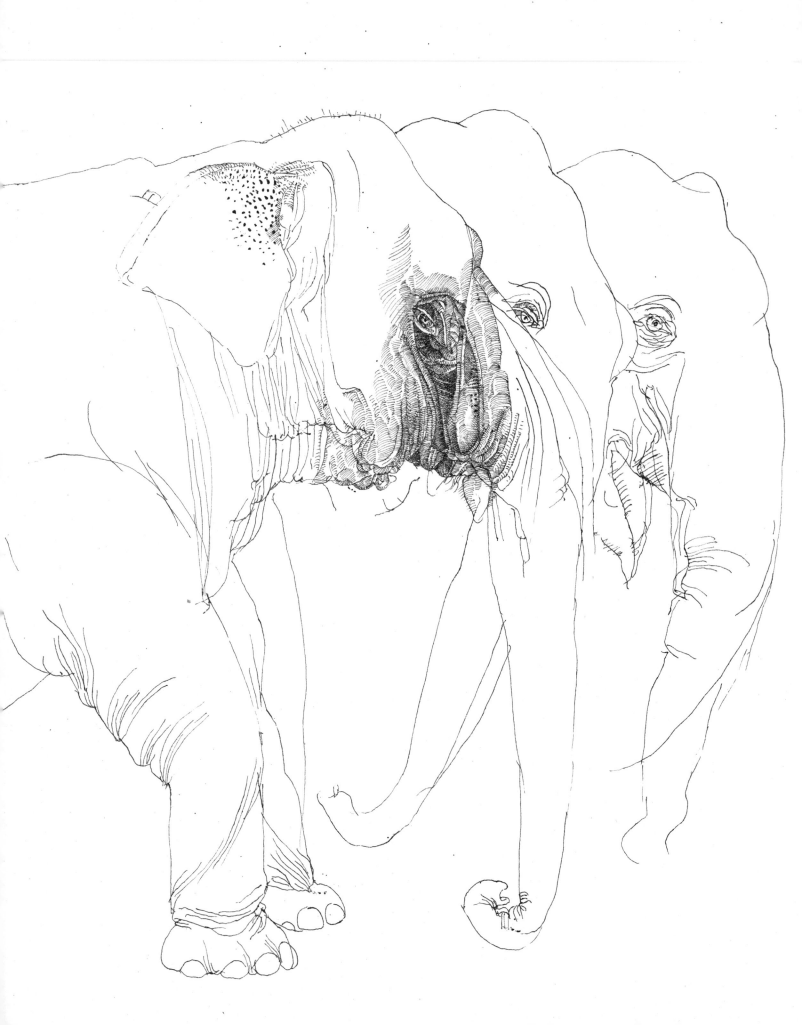

ELEPHANTS

Siam, Igi and Marcella...these Indian elephants were part of the Ringling Bros. and Barnum & Bailey Circus. I drew them at Madison Square Garden in New York. Marcella died last year at the age of fifty-four. (That's about as long as elephants usually live.)

Indian elephants are said to be gentler and more easily domesticated than African elephants. African elephants have larger, leafy ears and stand taller than these.

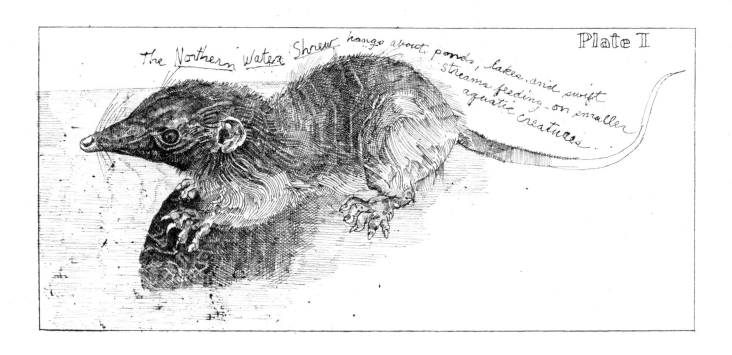

Plate II

The Northern Water Shrew hangs about ponds, lakes, and swift streams feeding on smaller aquatic creatures.

SHREW

No one cares enough about shrews to stuff one. They are very small and velvet-soft.
This shrew was drawn after my research in the New York Public Library—from photographs, natural history books and an encyclopedia.

MOSQUITO

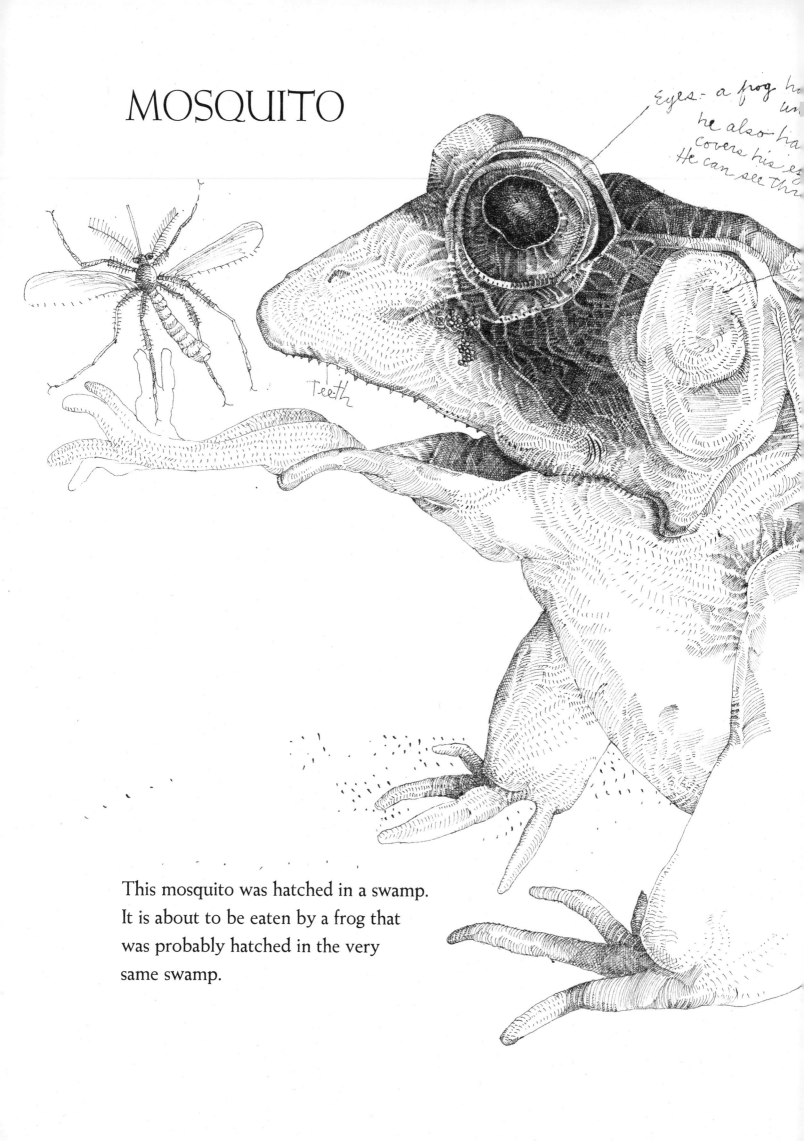

Eyes - a frog ha
un
he also ha
covers his e
He can see thr

teeth

This mosquito was hatched in a swamp.
It is about to be eaten by a frog that
was probably hatched in the very
same swamp.

top of his head so he can sit
n with only his eyes sticking out, looking for insects
lids, the inside lid
– water.

– Ears

Skin: A frog does not drink with his
mouth, he drinks with his skin.
when he sits in water it goes
through.

SKUNK

One of its glass eyes is gone and the moths got into it.
This skunk reminds me of an old pirate.

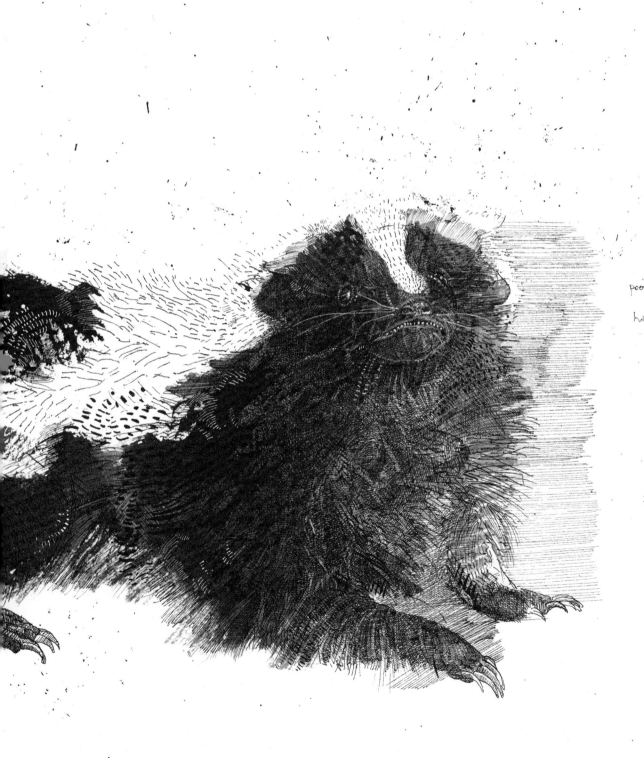

this was the worst looking
skunk I ever saw....
poorly stuffed :— with no
real shape. I think
he looks like a porcupine

Alan E. Cober '78

Alan E. Cober sees the world through glasses tinted by his own grudging humor and philosophy. He is acclaimed for his book illustrations and has won numerous gold and silver medals from the Society of Illustrators, as well as the Audubon Artists Creative Graphics Award.

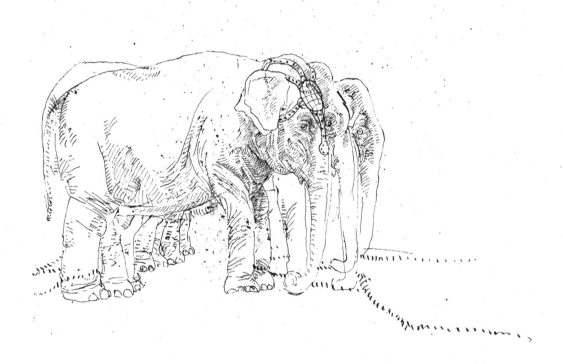

Alan E. Cober hand-lettered the title display type. The other display types are Bernhard Modern and Weiss Initials No. 1, both foundry. The text is set in Weiss Roman linotype. The art was prepared in pen and ink with wash. The book was printed by Halliday Lithographers.